The Enemy

A Biography of Wyndham Lewis

JEFFREY MEYERS

Routledge & Kegan Paul

BOSTON, LONDON, MELBOURNE AND HENLEY

First published in 1980
by Routledge & Kegan Paul Ltd

9 Park Street
Boston, Mass. 02108, USA

39 Store Street,
London WC1E 7DD

296 Beaconsfield Parade, Middle Park
Melbourne 3206, Australia and

Broadway House,
Newtown Road,
Henley-on-Thames
Oxon RG9 1EN

Set in 11/12 Monotype Imprint 101
Reprinted and first published as a paperback 1982
Printed in the United States of America

British Library Cataloguing in Publication Data
Meyers, Jeffrey
The enemy.
1. Lewis, Wyndham, b. 1882 - Biography
2. Authors, English - 20th century - Biography
3. Painters - England - Biography
4. Art critics - England - Biography
I. Title
828'.9'1209 PR6023.E97Z/

ISBN 0 7100 9351 9

Cover credits

(Front) Wyndham Lewis and The Laughing Woman, c. 1912
(courtesy of Barratt's Photo Press)
(Back) Alcibiades from Timon of Athens, 1912
(courtesy of the Victoria and Albert Museum)

For William Calder

Contents